Ch[...]013

Dear Baby Girl
Politano,

Looking so
forward to meeting
you. You parents
are amazing; You'll
love your nest,
and you'll love
them.

Love,
Amy & Keith
XOXO

A SKY FULL OF KINDNESS

ROB RYAN

CHRONICLE BOOKS

SAN FRANCISCO

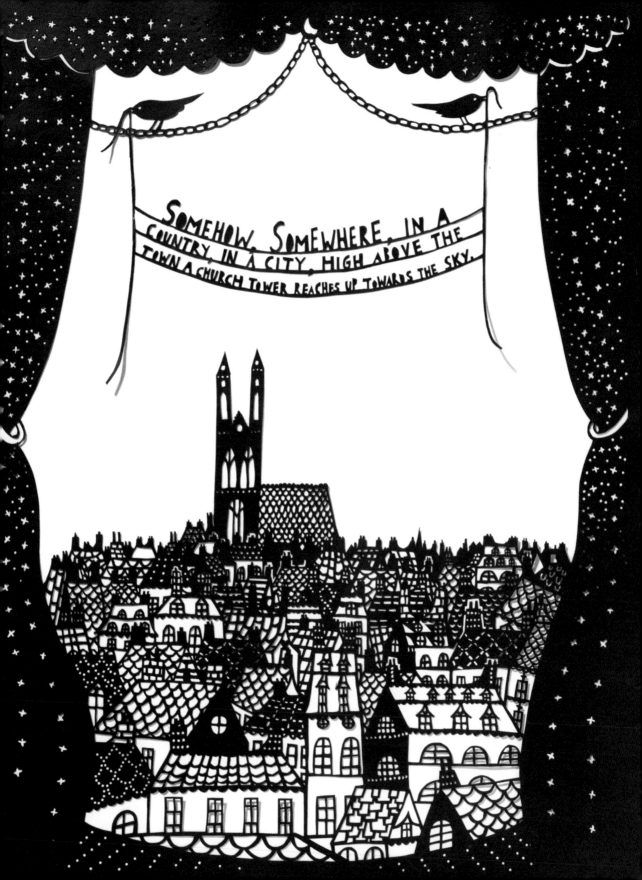

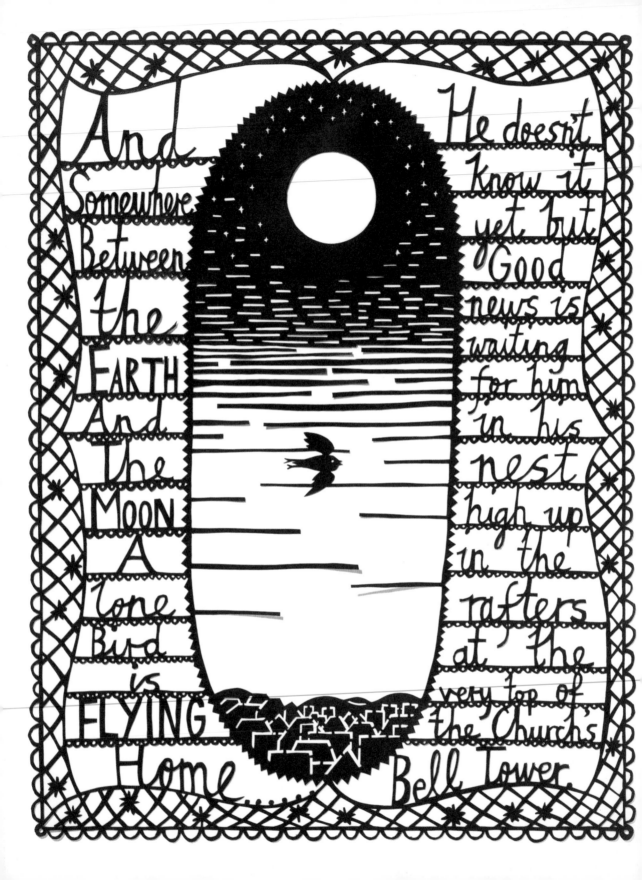

And Somewhere Between the EARTH And The Moon A Lone Bird is FLYING Home

He doesn't Know it yet but Good news is waiting for him in his nest high up in the rafters at the very top of the Churchs Bell Tower.

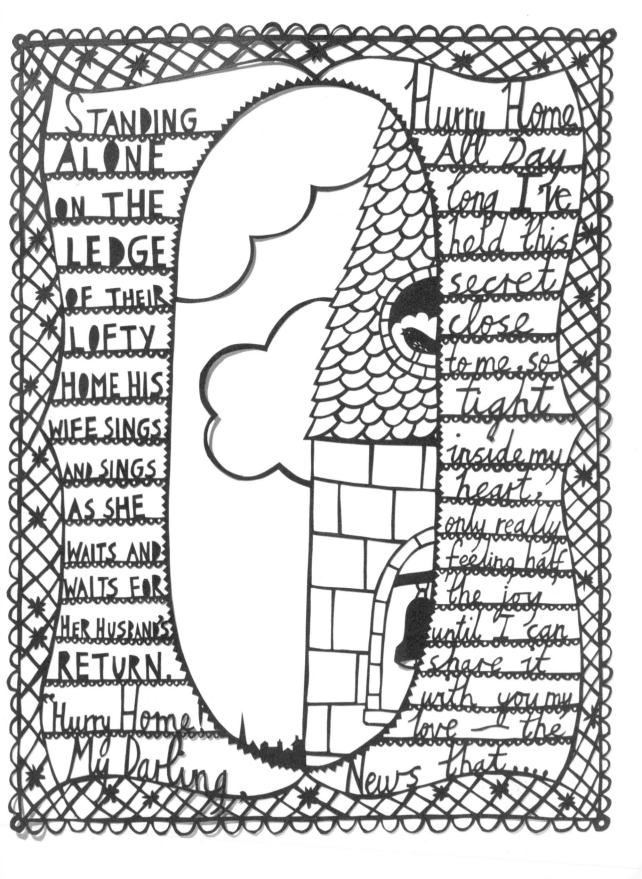

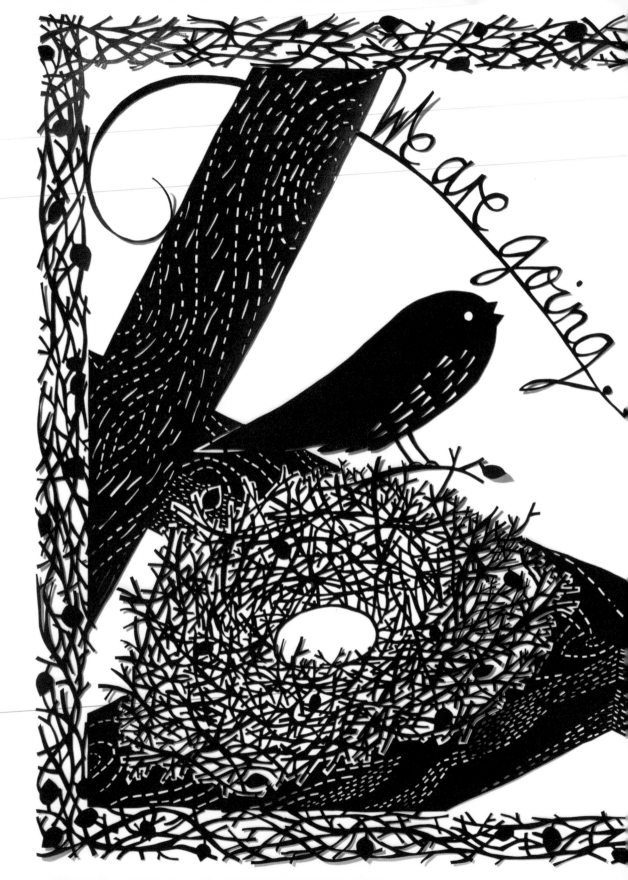

THE FATHER-TO-BE
TURNED UPON THE WINDOW
LEDGE TO FACE THE CITY
(IF NOT THE
ENTIRE WORLD)
THAT LAY SPREAD
OUT BENEATH
HIM.
......*......

AND SWELLED UP
WITH PRIDE HE
BURST OUT INTO
SONG - LOUDER
THAN HE HAD EVER
SUNG BEFORE.
......*.....

HE COULD NOT TELL YOU
WHERE THE WORDS CAME
FROM, HE CERTAINLY
DIDN'T PLAN THEM IN
HIS HEAD, THEY ROSE
DIRECTLY FROM HIS
HEART UP TO HIS BEAK
AND FROM THERE THEY
TRAVELLED OUT ACROSS
THE WHOLE TOWN
AND BEYOND......

.... *.....

LET ME TELL YOU, THIS WORLD IS A CRUEL AND HARSH PLACE FOR US BIRDS. IT SEEMS AS IF DANGER LIES IN WAIT FOR US AT EVERY TURN...

I'VE SEEN CHILDREN STOLEN FROM THEIR HOMES THAT HAVE NOT EVEN YET BEEN BORN!

AND IT CAN BE SO HARD TO WORK OUT WHAT IS DANGEROUS IN THIS WORLD AND WHAT IS NOT...

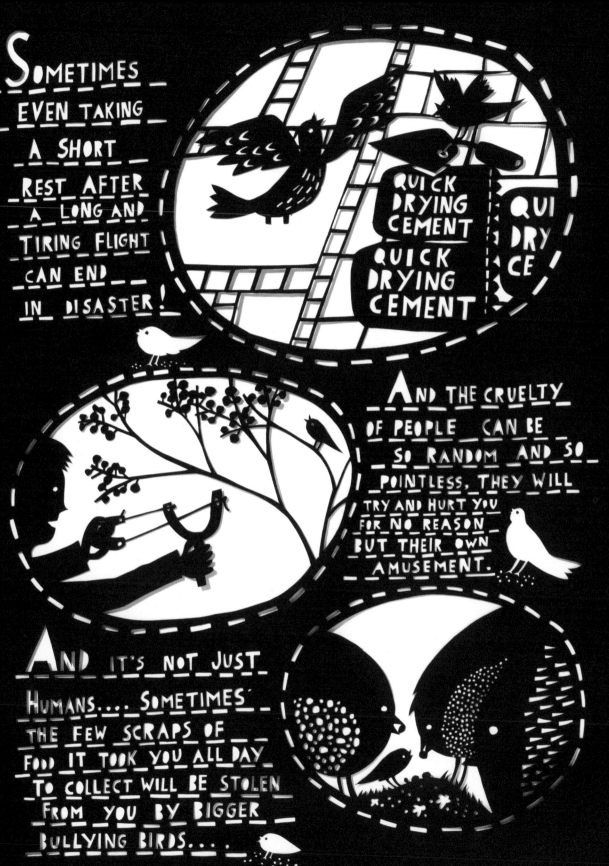

SOMETIMES EVEN TAKING A SHORT REST AFTER A LONG AND TIRING FLIGHT CAN END IN DISASTER!

QUICK DRYING CEMENT

QUICK DRYING CEMENT

QUI DRY CE

AND THE CRUELTY OF PEOPLE CAN BE SO RANDOM AND SO POINTLESS, THEY WILL TRY AND HURT YOU FOR NO REASON BUT THEIR OWN AMUSEMENT.

AND IT'S NOT JUST HUMANS.... SOMETIMES THE FEW SCRAPS OF FOOD IT TOOK YOU ALL DAY TO COLLECT WILL BE STOLEN FROM YOU BY BIGGER BULLYING BIRDS....

These wearisome tales of woe and fear went on and on and on until above all the hubbub a quavering high-pitched voice rang out,

"Be Quiet! Be Quiet! Let me through, Let me see the egg!"

All of the birds turned around and there standing before them was the oldest, tiniest, frailest and wisest bird you have ever seen. Some of the birds began to whisper......

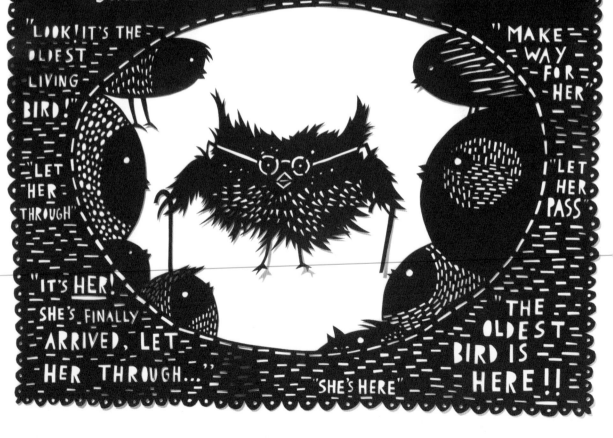

"Look! it's the oldest living bird!"

"Let her through"

"It's HER! she's finally arrived, let her through..."

"She's here"

"Make way for her"

"Let her pass"

The oldest bird is here!!

A Hush Falls as the oldest living bird very slowly makes her way to the egg, and ever so gently and ever so tenderly she leans over and KISSES it with her beak, then TURNING to face all of the assembled birds she solemnly says to them all,

"FRIENDS! Raise your Beaks to the SKY! And sing out loud with me the Ancient Blessing of the Egg."

The oldest bird bowed her head and began to sing, all the other birds joined in, singing THE SAME WORDS THAT HAVE BEEN sung over EVERY EGG THAT HAS EVER BEEN LAID since as Long as BIRDS can Remember...

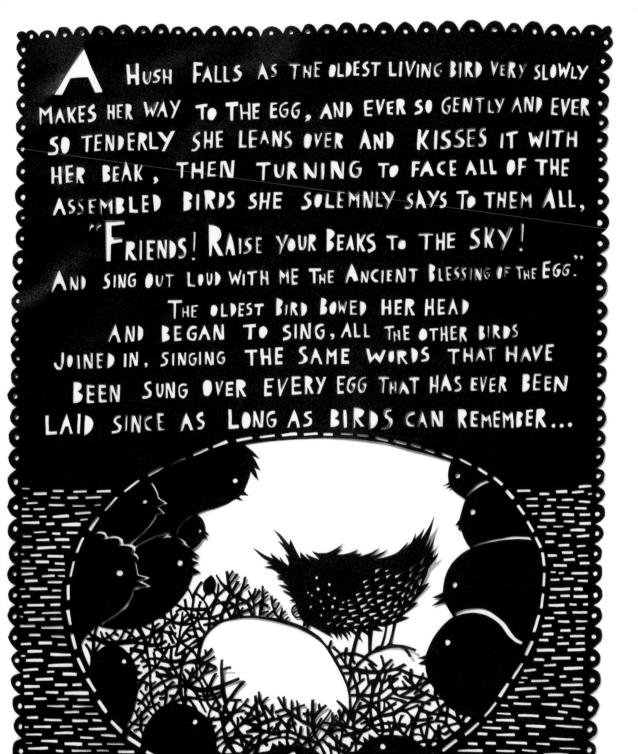

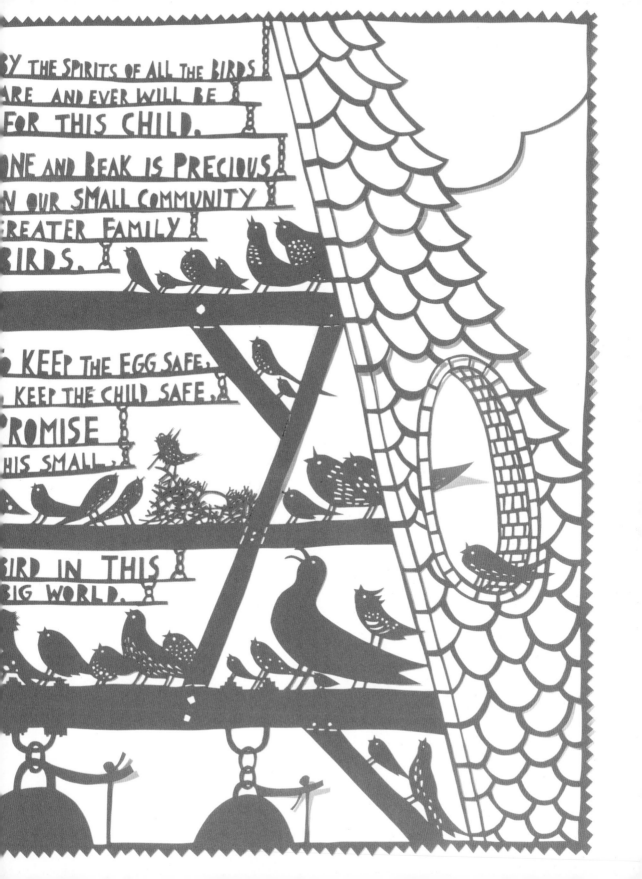

BY THE TIME
ALL OF THE VISITORS HAD
LEFT, DAY HAD BECOME
NIGHT AND AS THEY FLEW
AWAY IT SEEMED FOR A
MOMENT THAT THEY
BECAME ONE WITH
THE TWINKLING
STARS AS

THE

MOONLIGHT SHONE ON
THEIR FLUTTERING WINGS.
"I DON'T THINK I
HAVE EVER FELT HAPPIER"
HER HUSBAND SAID AS HE TURNED
TO LOOK AT HER, AND ALTHOUGH
SHE SMILED BACK AT HIM
HE NEVER SAW THE
TINY TEAR IN
HER EYE

Later that night as the two of them snuggle down inside their little nest, just before they closed their eyes, the wife whispers to her husband in the tiniest voice....

"I'M SCARED....AND I DON'T KNOW WHAT TO DO.....ALL OF THOSE TERRIBLE THINGS THAT PEOPLE SAID MIGHT HAPPEN HAVE BURIED THEMSELVES IN MY HEAD AND THEY WON'T GO AWAY AND NOW I'M SCARED THAT THEY WILL ALL COME TRUE......
...I SHOULD BE SO FULL OF JOY BUT INSTEAD I FEEL SO FULL OF FEAR...IT'S AS IF THERE ARE NOTHING BUT BAD THINGS OUT THERE IN THE WORLD LYING IN WAIT FOR MY CHILD. I DON'T KNOW WHAT TO DO AND I DON'T KNOW WHO TO TRUST...

HER HUSBAND LOOKED AT HER WITH CONCERN
AND LOVING TENDERNESS.
* * * * *
"IF YOU DON'T KNOW WHO TO TRUST THEN
MAYBE YOU SHOULD JUST TRUST EVERYBODY."

THEY BOTH LOOKED DOWN AT THE EGG LYING
BETWEEN THEM IN THEIR NEST. "WILL YOU JUST LOOK AT
THAT WONDERFUL EGG?" SAID THE HUSBAND, "HAVE YOU
EVER SEEN SUCH A SMALL THING FULL OF SO MUCH PROMISE?
IT TAKES ME BACK TO WHEN I WAS INSIDE MY OWN
EGG MANY YEARS AGO......"

The Husband's Egg Story.

"I REMEMBER WHEN BEFORE I WAS EVEN BORN, I WAS LIVING IN MY EGG WAITING AND GROWING UNTIL I WAS BIG ENOUGH TO LEAVE. I REMEMBER THAT IT WAS QUITE DARK IN THERE, EXCEPT THAT SOMETIMES A BRIGHT GLOW WOULD HOVER ABOVE ME. I USED TO STARE AT THAT MYSTERIOUS GLOW FOR HOURS ON END WONDERING WHAT IT COULD BE? (OF COURSE I REALISE NOW THAT IT WAS THE SUN!!) I KNEW THOUGH THAT SOMEHOW THERE MUST BE ANOTHER LIFE BEYOND THIS SLEEPY EXISTENCE IN MY LITTLE OVAL HOME, BUT

WHAT IT WAS I COULD NOT EVEN BEGIN TO UNDERSTAND. BUT I DO REMEMBER ONE THING — I WAS NOT AT ALL AFRAID, I WAS **EXCITED!!!** AND I WANTED TO FIND OUT WHAT WOULD HAPPEN NEXT!

"SO MY DARLING
CLOSE YOUR EYES AND DON'T BE AFRAID"
AND AS SHE DID HE SANG THIS SONG.....

ALL WE CAN DO IS
LIVE FROM DAY TO DAY
AND I WANT TO
GROW OLD WITH YOU
UNTIL MY FEATHERS
GO GREY AND MY BEAK
WRINKLES UP AND MY WINGS ARE
TOO WEAK TO FLY, ALL WE CAN
DO IS LIVE FROM DAY TO DAY

AND AS HE WHISPERED
THESE WORDS TO HER SHE FELL
FAST ASLEEP.

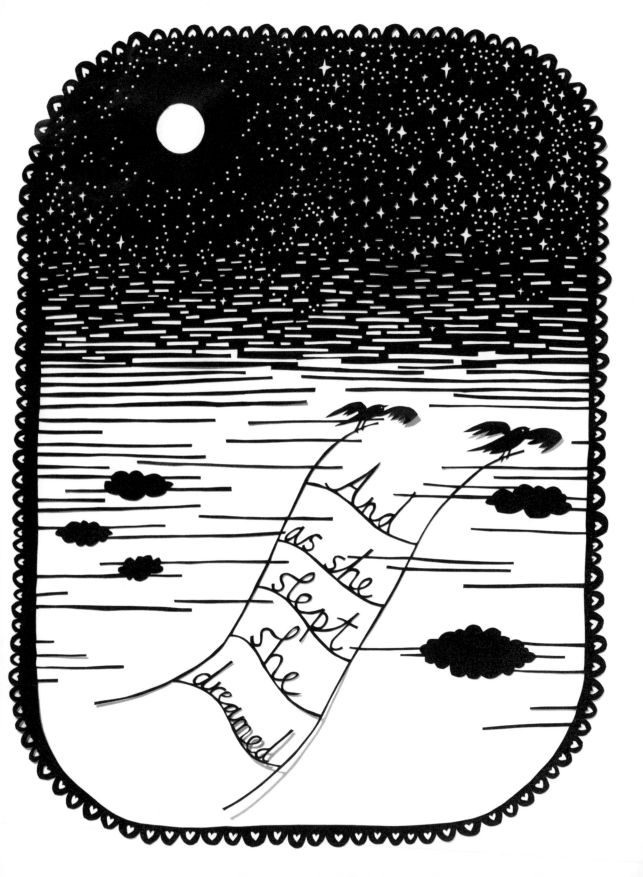

THE FOLLOWING MORNING THE WIFE WOKE HER HUSBAND WITH A START AND TOLD HIM ALL ABOUT AN INCREDIBLE DREAM THAT SHE HAD IN THE NIGHT.

"I DON'T KNOW WHAT IT MEANT" SHE SAID, "BUT I'M SURE THAT IT WAS VERY IMPORTANT!"

"WHAT WE SHOULD DO" (SAID HER HUSBAND) "IS FIND THE OLDEST BIRD AND TELL HER... I'M SURE THAT SHE WILL KNOW WHAT TO DO."

*

SO THIS IS EXACTLY WHAT THEY DID.

"YOU WERE RIGHT TO COME TO SEE ME, (SAID THE OLDEST BIRD) OUR DREAMS HOLD TRUTHS THAT WE HIDE FROM OUR WAKING MINDS. NOW, TELL ME ALL ABOUT YOUR DREAM...."

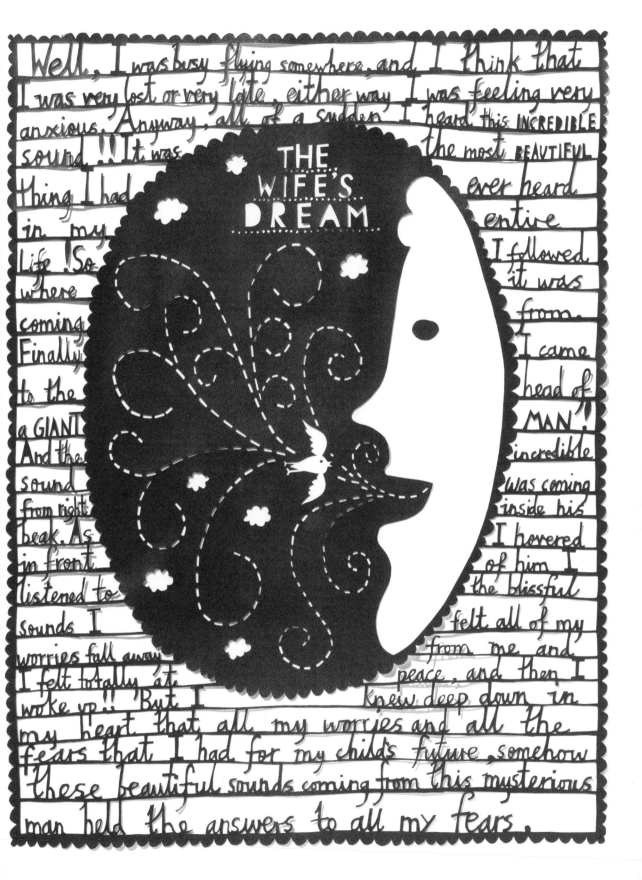

Well, I was busy flying somewhere, and I think that I was very lost or very late, either way I was feeling very anxious. Anyway, all of a sudden [I] heard this INCREDIBLE sound... It was the most BEAUTIFUL thing I had ever heard in my entire life! So where it was coming from. Finally I came to the head of a GIANT MAN! And the incredible sound from right was coming beak. As inside his in front I hovered listened to of him I sounds I the blissful worries fall away felt all of my I felt totally at from me and woke up!! But I peace, and then I knew deep down in my heart that all my worries and all the fears that I had for my child's future, somehow these beautiful sounds coming from this mysterious man held the answers to all my fears.

THE WIFE'S DREAM

THE OLDEST BIRD STOOD THERE DEEP IN THOUGHT FOR A FEW MINUTES, FINALLY SHE SPOKE. "YOU ARE RIGHT, THIS IS A VERY SIGNIFICANT DREAM INDEED. I KNOW WHO THIS MAN YOU DREAMT OF IS, HE CAN HELP YOU IF ANYONE CAN. YOU MUST FLY EAST AS FAR AS YOU CAN IF YOU WANT TO FIND HIM, ONLY THEN WILL YOUR TROUBLED SOUL BE SETTLED. FLY EAST."

"FLY EAST?" SAID THE WIFE BIRD "BUT I DON'T KNOW WHICH WAY EAST IS!" THE OLDEST BIRD LOOKED AT HER WITH EYES THAT WERE FULL OF KINDNESS AND CONCERN. "THEY MAY NOT KNOW IT, BUT ALL BIRDS DEEP INSIDE THEMSELVES ALWAYS KNOW IN WHICH DIRECTION NORTH, EAST, WEST & SOUTH LIE! IT'S BURIED SOMEWHERE INSIDE US ALL, YOU JUST HAVE TO TRUST IN YOURSELF. LUCKILY FOR YOU THE MIGRATING BIRDS ARE ALL FLYING OVERHEAD RIGHT NOW, FOLLOW THEM! THEY ARE FLYING EAST, BUT YOU MUST LEAVE RIGHT AWAY! SOON THEY WILL ALL HAVE FLOWN AWAY. GO NOW!! FLY EAST! BEFORE IT'S TOO LATE! GO NOW!

AND THEY CALLED BACK TO EACH OTHER UNTIL FINAL

THE WIFE TURNED TO LOOK AT HER HUSBAND BUT NO WORDS CAME OUT OF HER BEAK, NO WORDS EXISTED THAT COULD EXPLAIN EVERYTHING THAT SHE FELT INSIDE, BUT HER HUSBAND'S LOVE FOR HER WAS THE TYPE THAT DIDN'T EVEN NEED WORDS.

"YOU MUST GO" HE SOFTLY SAID TO HER "AND RIGHT NOW IS THE RIGHT TIME. DON'T WORRY, I WILL WAIT FOR YOU." AND HE KISSED HER. AND FULL OF TREPIDATION AND FEAR AND HOPE THIS SMALL, BRAVE BIRD FLEW UP AND UP AND UP INTO THE ENORMOUS SKY WHERE SHE TAGGED ON TO THE TAIL-END OF ONE OF THE GIANT V-SHAPED LINES OF BIRDS HEADING EAST THAT FILLED THE SKY. "I WILL WAIT" HER HUSBAND CALLED OUT AS SHE FLEW AWAY SLOWLY GETTING SMALLER & SMALLER, AND SHE CALLED BACK TO HIM AS SHE FLEW "I WILL RETURN."

WILL WAIT... I WILL RETURN... I WILL WAIT... I WILL
THE WIND CARRIED ... I WILL RETURN... I WILL WAIT... I WILL RETURN...
WILL WAIT... ALL OF THEIR WORDS AWAY...

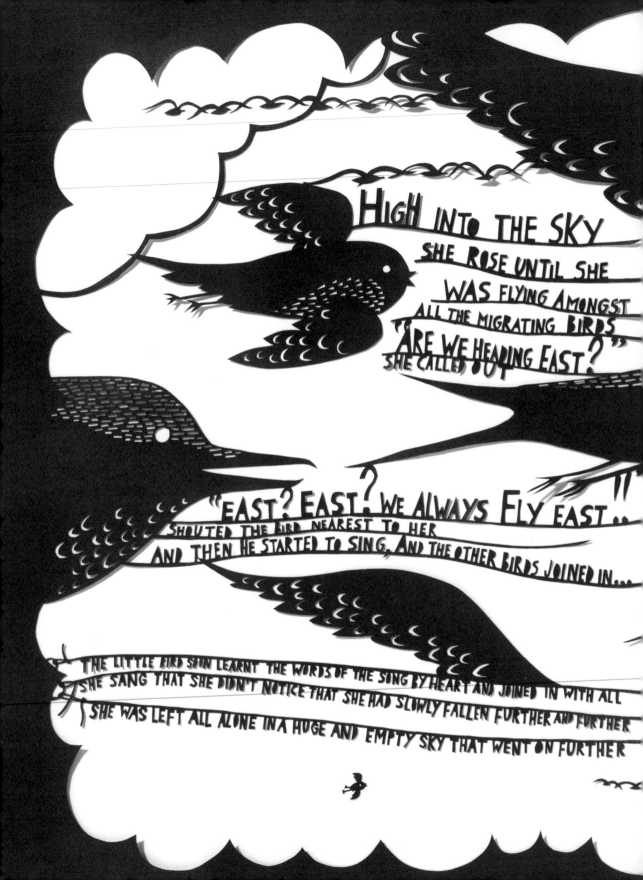

HIGH INTO THE SKY SHE ROSE UNTIL SHE WAS FLYING AMONGST ALL THE MIGRATING BIRDS "ARE WE HEADING EAST?" SHE CALLED OUT

"EAST? EAST? WE ALWAYS FLY EAST..!!" SHOUTED THE BIRD NEAREST TO HER AND THEN HE STARTED TO SING, AND THE OTHER BIRDS JOINED IN....

THE LITTLE BIRD SOON LEARNT THE WORDS OF THE SONG BY HEART AND JOINED IN WITH ALL SHE SANG THAT SHE DIDN'T NOTICE THAT SHE HAD SLOWLY FALLEN FURTHER AND FURTHER SHE WAS LEFT ALL ALONE IN A HUGE AND EMPTY SKY THAT WENT ON FURTHER

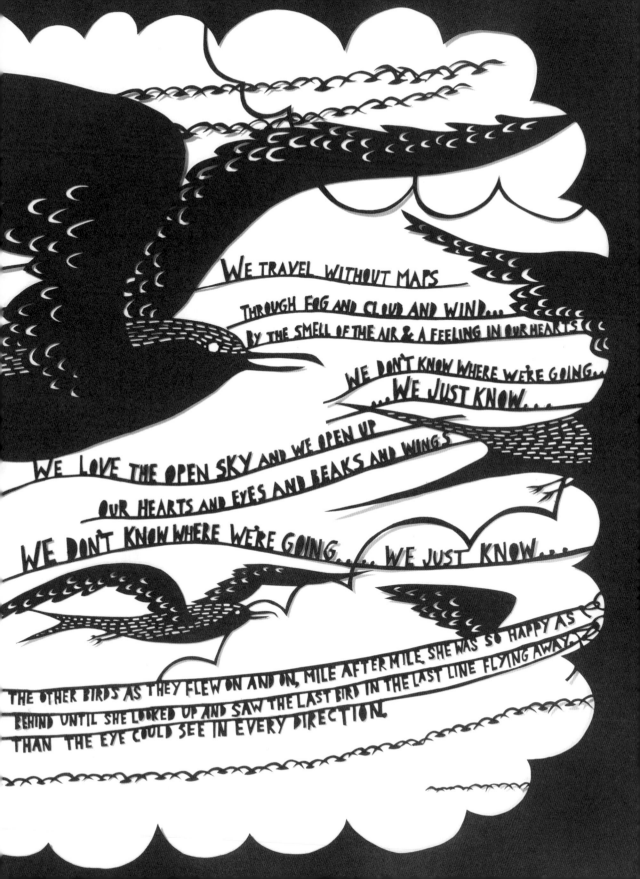

WE TRAVEL WITHOUT MAPS
THROUGH FOG AND CLOUD AND WIND...
BY THE SMELL OF THE AIR & A FEELING IN OUR HEARTS.
WE DON'T KNOW WHERE WE'RE GOING...
...WE JUST KNOW....

WE LOVE THE OPEN SKY AND WE OPEN UP
OUR HEARTS AND EYES AND BEAKS AND WINGS
WE DON'T KNOW WHERE WE'RE GOING..... WE JUST KNOW....

THE OTHER BIRDS AS THEY FLEW ON AND ON, MILE AFTER MILE SHE WAS SO HAPPY AS
BEHIND UNTIL SHE LOOKED UP AND SAW THE LAST BIRD IN THE LAST LINE FLYING AWAY,
THAN THE EYE COULD SEE IN EVERY DIRECTION.

"You don't realise how big the sky really is until you are all alone right in the middle of it" SHE THOUGHT AS SHE FLEW ON HER WAY THROUGH THE CLOUDS

"I wish that I had bigger wings. Then I could have kept up with them all."

"Do you mean like mine?" Said a deep voice behind her AND WHEN SHE TURNED AND LOOKED BACK THERE WAS THE LARGEST BIRD WITH THE BIGGEST BEAK AND THE KINDEST FACE SHE HAD EVER SEEN!! HE WAS, OF COURSE, A PELICAN!!!

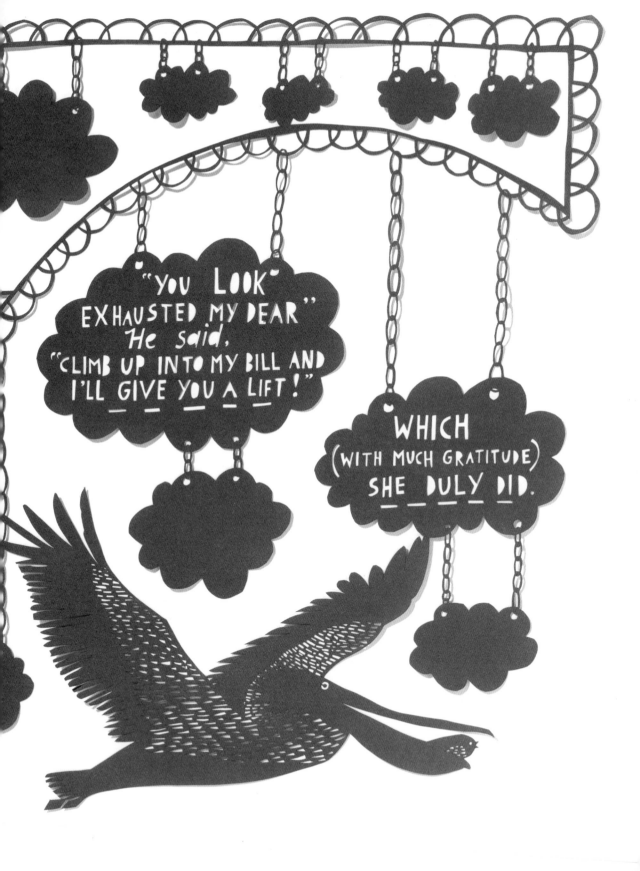

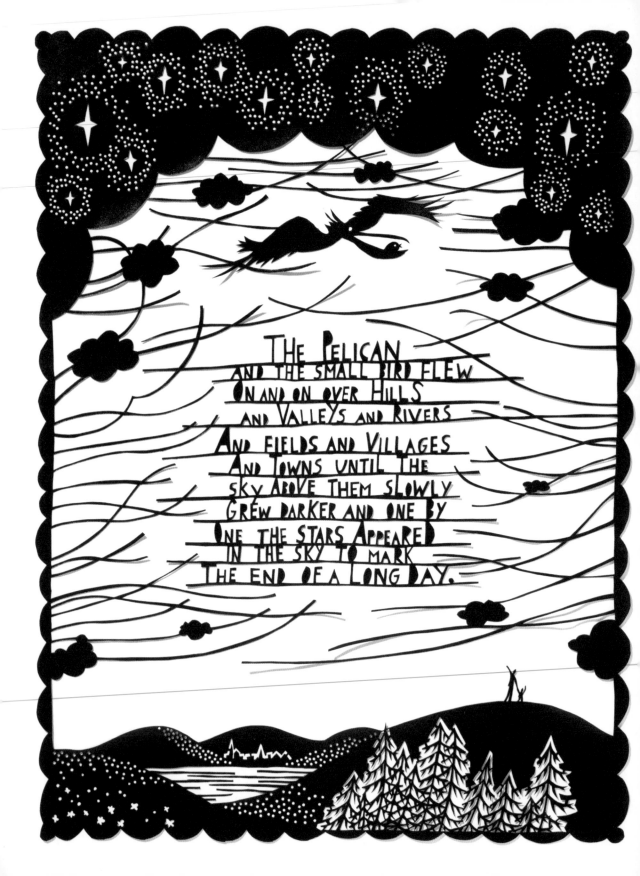

THE PELICAN
AND THE SMALL BIRD FLEW
ON AND ON OVER HILLS
AND VALLEYS AND RIVERS
AND FIELDS AND VILLAGES
AND TOWNS UNTIL THE
SKY ABOVE THEM SLOWLY
GREW DARKER AND ONE BY
ONE THE STARS APPEARED
IN THE SKY TO MARK
THE END OF A LONG DAY.

SOON AFTER, THEY FLEW OVER A
SMALL TOWN. THE PELICAN SWEPT DOWN TO
LAND UPON A ROOFTOP WHERE A VERY SERIOUS-LOOKING
BIRD SAT. "YOUNG LADY, THIS IS AN OLD FRIEND OF
(THE PELICAN DIDN'T INTRODUCE HIM BY NAME, UNLIKE US-BIRDS DON'T
MINE, I'M ONLY A, TIRED OLD PELICAN AND I CAN
GIVE THEMSELVES NAMES!)
ONLY FLY SO FAR, BUT HE WILL HELP YOU ON YOUR
JOURNEY, I HOPE YOU WILL BE FRIENDS." AND ALTHOUGH
SHE WAS NERVOUS AND A BIT SCARED OF THE STRANGER
SHE BRAVELY FORCED HERSELF TO SAY "HELLO" AS
POLITELY AS SHE COULD.

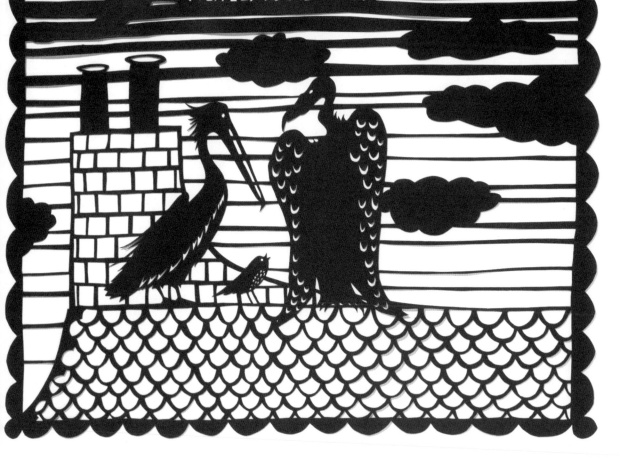

BUT BEFORE SHE COULD SAY ANOTHER
WORD THERE WAS A DEAFENING BANG!
AND A BLINDING FLASH! UP ABOVE THEM,
AND THE DARK NIGHT SKY ERUPTED INTO A FIERY INFERNO
OF A THOUSAND EXPLOSIONS!!
 "THE END OF THE WORLD IS HERE! THE HUMANS HAVE SET FIRE TO
THE SKY, THEY ARE FINALLY GOING TO BLOW UP THE ENTIRE WORLD!" SCREAMED
THE LITTLE BIRD. "BE QUIET! WE MUST LEAVE RIGHT NOW! UPWARDS! STAY
CLOSE TO ME AND FLY UP." THE MYSTERIOUS STRANGER HAD FINALLY SPOKEN.

THE TWO OF THEM ROSE HIGH INTO THE SKY THE STRANGER WITH SLOW AND POWERFUL STROKES OF HIS HUGE AND MIGHTY WINGS AND THE LITTLE

BIRD FLAPPING FURIOUSLY WITH HER TINY WINGS FRANTICALLY TRYING TO KEEP UP AND SHOUTING OUT AS SHE FLEW UP EVER HIGHER AND HIGHER. "GOODBYE MY PELICAN FRIEND, THANK YOU FOR ALL THE KINDNESS YOU SHOWED ME, I'LL NEVER EVER FORGET YOU! GOODBYE MY FRIEND!"

AND SO HIGH THEY FLEW THAT THE BANGS AND THE EXPLOSIONS GREW QUIETER AND QUIETER, AND THE GIANT FLASHES OF LIGHT THAT ONCE FILLED THE ENTIRE SKY NOW LOOKED LIKE A MAGICAL AND BEAUTIFUL FLOWER BED, FLASHING AND CHANGING COLOUR, FAR, FAR BENEATH THEM.

So High they flew that eventually all of the noise of the Earth became silent.

"Here is where I really live. High above the highest clouds. Seven human miles up, where all is still and peaceful." And as they flew the giant bird told her all about himself and his family (FOR HE WAS A RUPPELL'S GRIFFON, A VULTURE THAT IS ONE OF THE HIGHEST-FLYING OF ALL BIRDS!) and how they originally lived on the moon but some of them got lost and became trapped on Earth, held prisoner by its gravity. He told her how they were always trying to fly higher and higher in the hope that one day they might break free of this noisy planet and return to their real home in the silence and peace of SPACE.

The mother bird had never heard such incredible stories before and when she began to tell the Ruppell's Griffon about her little egg and all of her fears for her child's future, her dream and the journey she was making, she felt as if her problems were

far too small for someone so big to understand. But the enormous bird listened intently to every word she said, and only when she had finished telling her story did he finally speak "LOOK DOWN, LOOK DOWN MY LITTLE FRIEND, DO YOU SEE THOSE TINY SPECKS OF LIGHT DOWN THERE? THEY ARE THE EXPLOSIONS THAT FILLED THE SKY THAT YOU WERE SO SCARED OF NOT SO LONG AGO! HOW COULD ANY BIRD EVER BE SCARED OF ANY-THING SO INCREDIBLY MINUTE AND INSIGNIFICANT?!

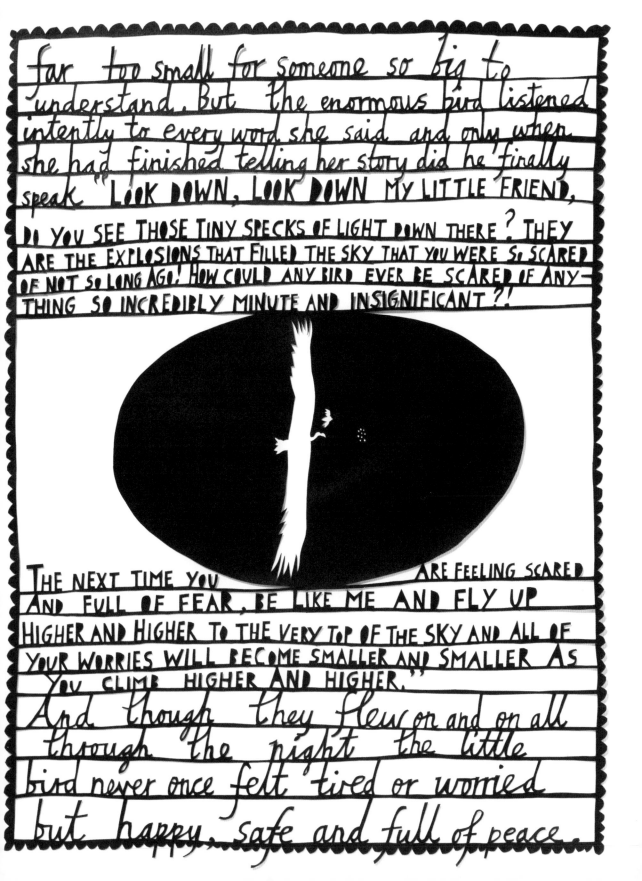

THE NEXT TIME YOU ARE FEELING SCARED AND FULL OF FEAR, BE LIKE ME AND FLY UP HIGHER AND HIGHER TO THE VERY TOP OF THE SKY AND ALL OF YOUR WORRIES WILL BECOME SMALLER AND SMALLER AS YOU CLIMB HIGHER AND HIGHER." And though they flew on and on all through the night the little bird never once felt tired or worried but happy, safe and full of peace.

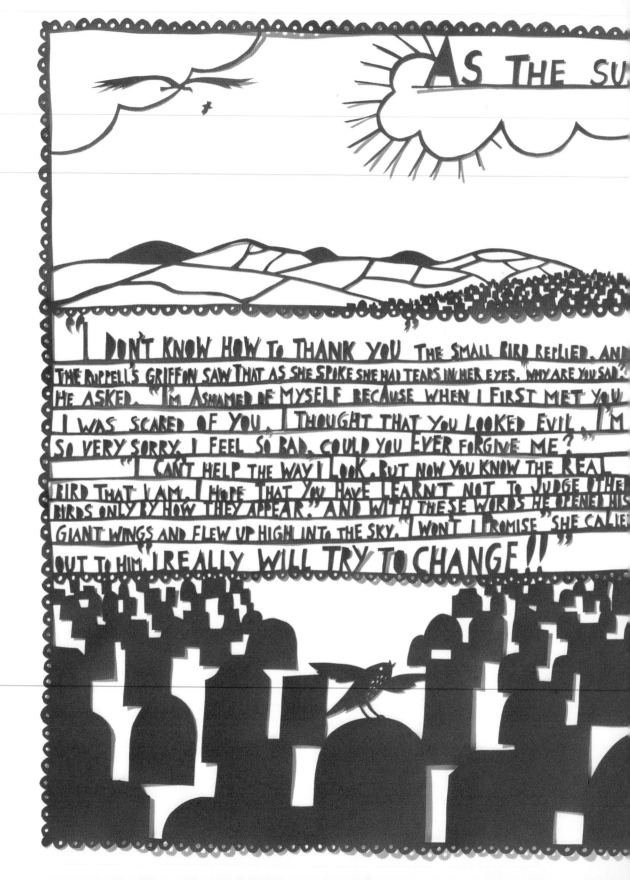

"I DON'T KNOW HOW TO THANK YOU" THE SMALL BIRD REPLIED, AND THE RUPPELL'S GRIFFON SAW THAT AS SHE SPOKE SHE HAD TEARS IN HER EYES. "WHY ARE YOU SAD?" HE ASKED. "I'M ASHAMED OF MYSELF BECAUSE WHEN I FIRST MET YOU I WAS SCARED OF YOU. I THOUGHT THAT YOU LOOKED EVIL. I'M SO VERY SORRY. I FEEL SO BAD. COULD YOU EVER FORGIVE ME?" "I CAN'T HELP THE WAY I LOOK. BUT NOW YOU KNOW THE REAL BIRD THAT I AM. I HOPE THAT YOU HAVE LEARNT NOT TO JUDGE OTHER BIRDS ONLY BY HOW THEY APPEAR." AND WITH THESE WORDS HE OPENED HIS GIANT WINGS AND FLEW UP HIGH INTO THE SKY. "I WON'T I PROMISE" SHE CALLED OUT TO HIM. I REALLY WILL TRY TO CHANGE!!

ROSE AHEAD OF THEM IN THE EAST THEY BEGAN TO SLOWLY DESCEND DOWN THROUGH THE CLOUDS. THE COMPLEX PATTERN OF SQUARES BENEATH TURNED OUT TO BE FIELD AFTER FIELD. AND THE TINY SQUIGGLY LINES BECAME LONG AND WIDE-FLOWING RIVERS.

THEY CAME DOWN TO LAND IN A GIANT FIELD UNLIKE ANY OF THE OTHERS. FILLED WITH THOUSANDS OF DIFFERENT SIZED AND SHAPED STONES. THE GIANT VULTURE SAID TO THE LITTLE BIRD "I AM GOING TO HAVE TO LEAVE YOU HERE I'M AFRAID. BUT THE BIRDS THAT LIVE IN THIS PLACE ARE KIND, AND I'M SURE THEY WILL HELP YOU ON YOUR WAY."

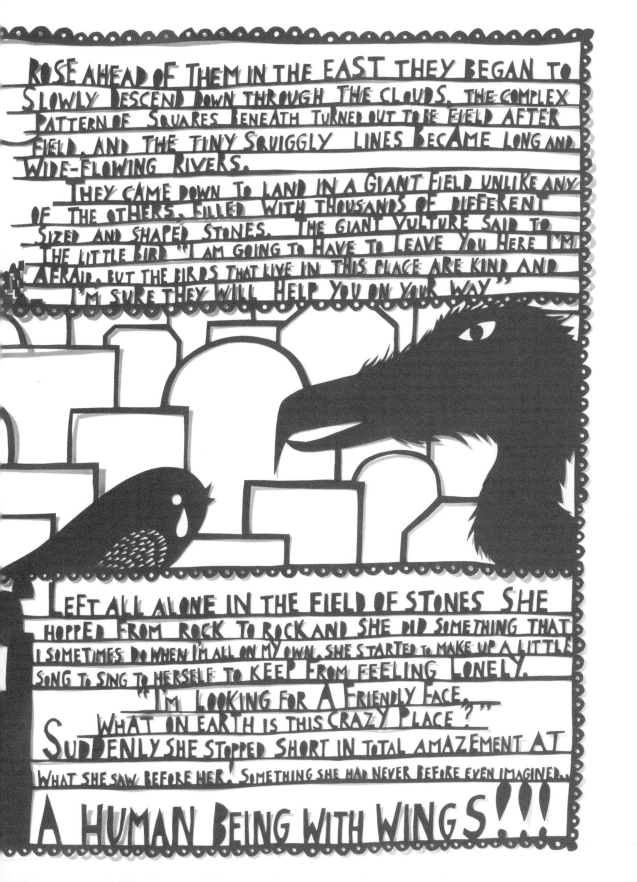

LEFT ALL ALONE IN THE FIELD OF STONES SHE HOPPED FROM ROCK TO ROCK AND SHE DID SOMETHING THAT I SOMETIMES DO WHEN I'M ALL ON MY OWN. SHE STARTED TO MAKE UP A LITTLE SONG TO SING TO HERSELF TO KEEP FROM FEELING LONELY.

"I'M LOOKING FOR A FRIENDLY FACE.
WHAT ON EARTH IS THIS CRAZY PLACE?"
SUDDENLY SHE STOPPED SHORT IN TOTAL AMAZEMENT AT WHAT SHE SAW BEFORE HER. SOMETHING SHE HAD NEVER BEFORE EVEN IMAGINED...

A HUMAN BEING WITH WINGS!!!

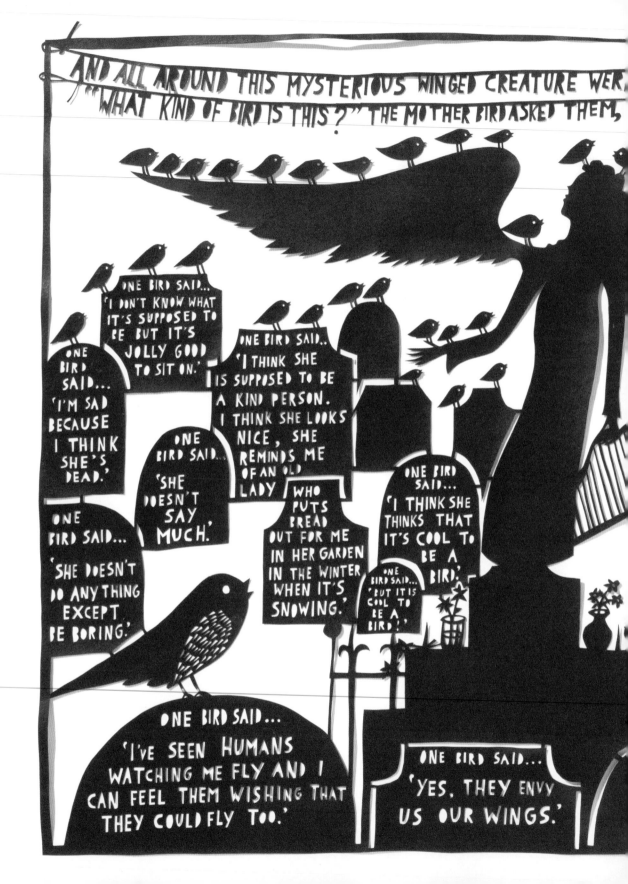

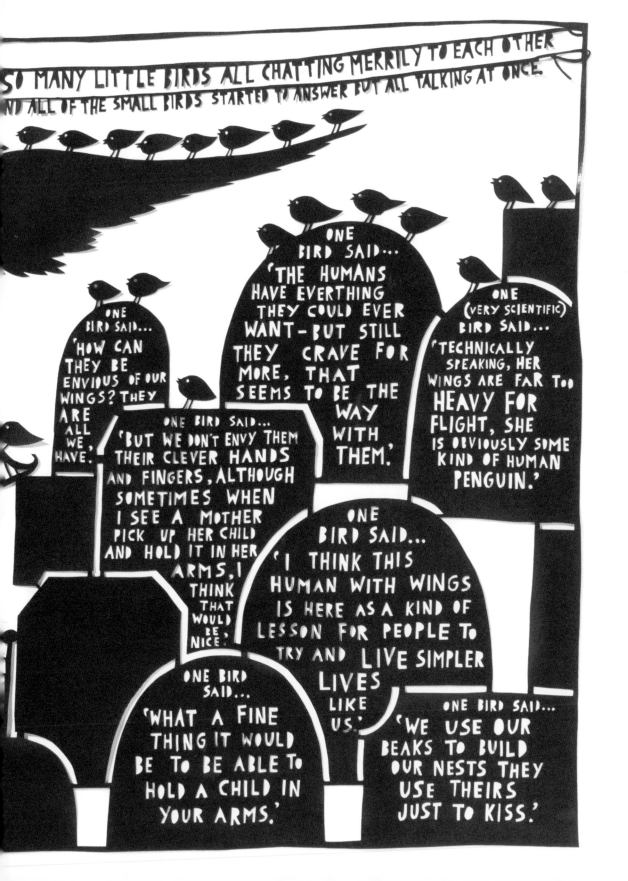

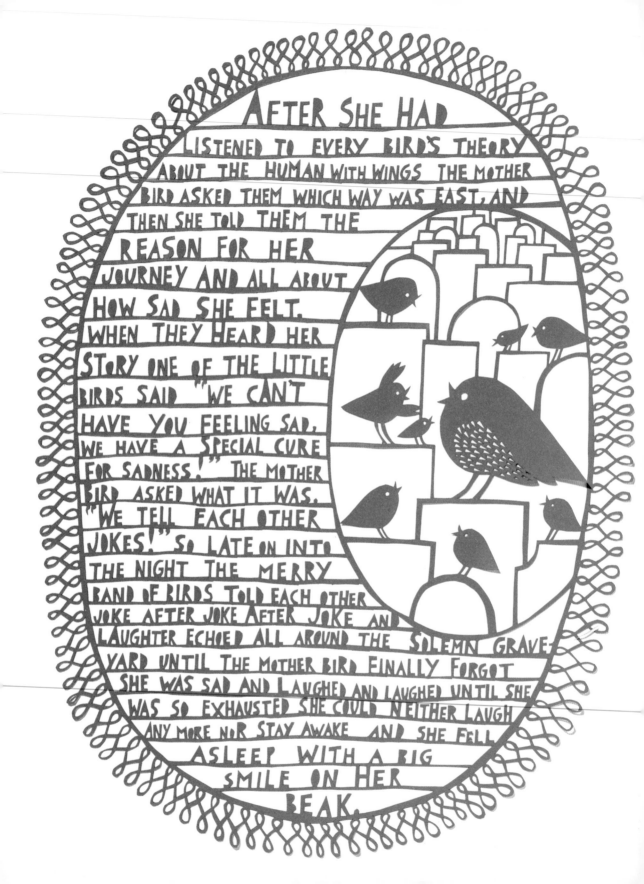

AFTER SHE HAD LISTENED TO EVERY BIRD'S THEORY ABOUT THE HUMAN WITH WINGS THE MOTHER BIRD ASKED THEM WHICH WAY WAS EAST, AND THEN SHE TOLD THEM THE REASON FOR HER JOURNEY AND ALL ABOUT HOW SAD SHE FELT. WHEN THEY HEARD HER STORY ONE OF THE LITTLE BIRDS SAID "WE CAN'T HAVE YOU FEELING SAD, WE HAVE A SPECIAL CURE FOR SADNESS." THE MOTHER BIRD ASKED WHAT IT WAS. "WE TELL EACH OTHER JOKES!" SO LATE ON INTO THE NIGHT THE MERRY BAND OF BIRDS TOLD EACH OTHER JOKE AFTER JOKE AFTER JOKE AND LAUGHTER ECHOED ALL AROUND THE SOLEMN GRAVE-YARD UNTIL THE MOTHER BIRD FINALLY FORGOT SHE WAS SAD AND LAUGHED AND LAUGHED UNTIL SHE WAS SO EXHAUSTED SHE COULD NEITHER LAUGH ANY MORE NOR STAY AWAKE AND SHE FELL ASLEEP WITH A BIG SMILE ON HER BEAK.

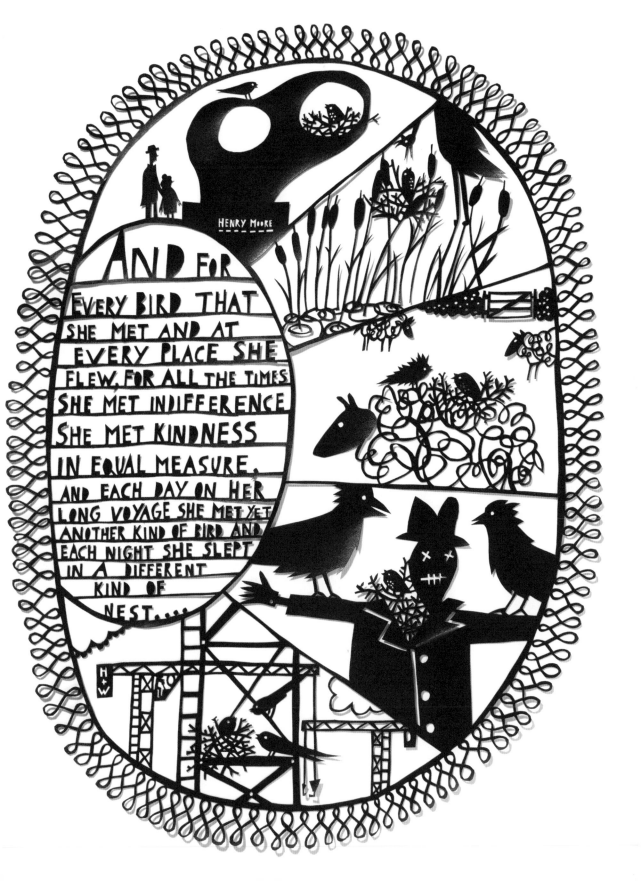

HENRY MOORE

AND FOR EVERY BIRD THAT SHE MET AND AT EVERY PLACE SHE FLEW, FOR ALL THE TIMES SHE MET INDIFFERENCE SHE MET KINDNESS IN EQUAL MEASURE, AND EACH DAY ON HER LONG VOYAGE SHE MET YET ANOTHER KIND OF BIRD AND EACH NIGHT SHE SLEPT IN A DIFFERENT KIND OF NEST....

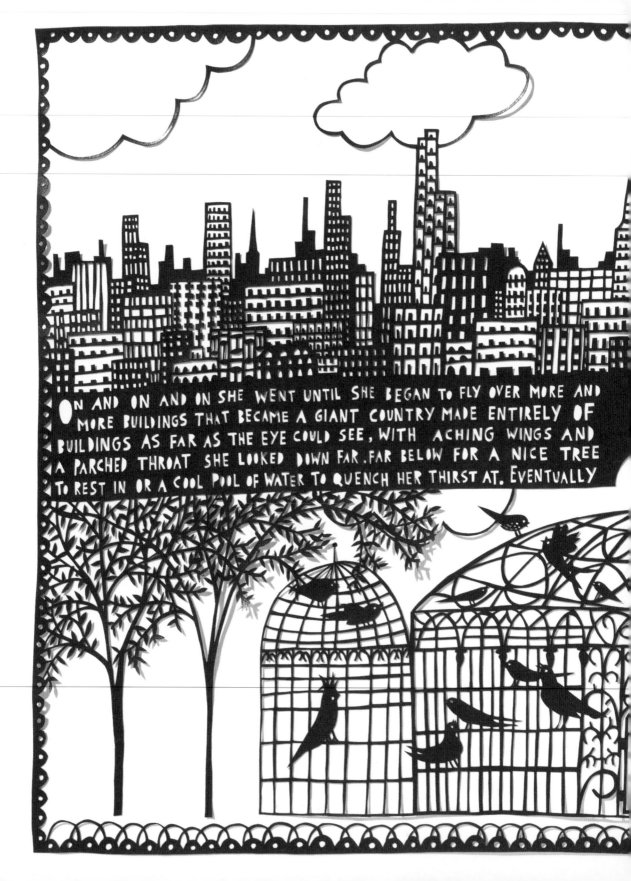

On and on and on she went until she began to fly over more and more buildings that became a giant country made entirely of buildings as far as the eye could see, with aching wings and a parched throat she looked down far, far below for a nice tree to rest in or a cool pool of water to quench her thirst at. Eventually

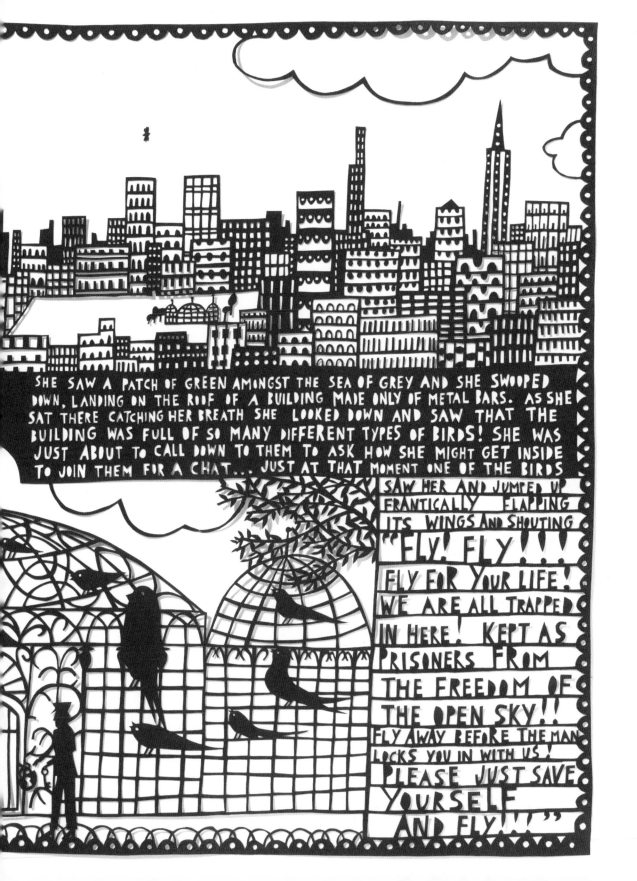

SHE SAW A PATCH OF GREEN AMONGST THE SEA OF GREY AND SHE SWOOPED DOWN, LANDING ON THE ROOF OF A BUILDING MADE ONLY OF METAL BARS. AS SHE SAT THERE CATCHING HER BREATH SHE LOOKED DOWN AND SAW THAT THE BUILDING WAS FULL OF SO MANY DIFFERENT TYPES OF BIRDS! SHE WAS JUST ABOUT TO CALL DOWN TO THEM TO ASK HOW SHE MIGHT GET INSIDE TO JOIN THEM FOR A CHAT... JUST AT THAT MOMENT ONE OF THE BIRDS SAW HER AND JUMPED UP FRANTICALLY FLAPPING ITS WINGS AND SHOUTING "FLY! FLY!!! FLY FOR YOUR LIFE! WE ARE ALL TRAPPED IN HERE! KEPT AS PRISONERS FROM THE FREEDOM OF THE OPEN SKY!! FLY AWAY BEFORE THE MAN LOCKS YOU IN WITH US! PLEASE JUST SAVE YOURSELF AND FLY!!!"

FULL OF HORROR SHE SUDDENLY REALISED WHAT THE BUILDING TRULY WAS AND FEELING TORN BETWEEN WANTING TO HELP THE POOR IMPRISONED BIRDS AND THE TERROR OF BEING CAUGHT HERSELF SHE FLED. ALL SHE WANTED WAS TO BE AS FAR AWAY FROM THAT AWFUL PLACE AS POSSIBLE, NOT KNOWING WHERE SHE WAS OR WHERE SHE WAS GOING SHE FLEW BETWEEN THE TOWERING BUILDINGS, HER HEART POUNDING SO HARD SHE THOUGHT IT MIGHT BURST RIGHT OUT OF HER CHEST! HER WINGS WERE TREMBLING AS SHE TRIED TO FLY, AND THE NOISY SOUNDS RISING UP FROM THE STREETS ECHOED ALL AROUND, MAKING HER FEEL WOBBLY AND CONFUSED UNTIL SHE FELT SO DIZZY THAT SHE STARTED TO FEEL FAINT AND EVERYTHING SHE SAW WENT FUZZY AND THEN BLACK. AND SHE FELL DOWN INTO THE GUTTER WHERE THE PEOPLE PASSING BY IGNORED HER AND CARRIED ON WALKING BY THINKING TO THEMSELVES "JUST YET ANOTHER DEAD BIRD."

HOW LONG SHE LAY THERE SHE NEVER FOUND OUT BUT ONE SINGLE TINY BIRD SAW HER LYING THERE ALL ALONE, HE CALLED OUT TO ANOTHER BIRD AND THEN ANOTHER UNTIL SOON A SMALL CLUSTER OF THESE TINY BIRDS OF THE CITY WERE GATHERED ALL AROUND HER. FIRST ONE BIRD TRIED TO GET BENEATH HER AND LIFT HER UP AND THEN ANOTHER TRIED UNTIL THEY ALL GOT UNDER HER AND ALL AROUND HER AND THEY ALL LIFTED HER UP INTO THE AIR AND CARRIED HER BACK, STILL UNCONSCIOUS AND WITH MUCH EFFORT, BACK TO THEIR HOME WHERE THEY LAID HER DOWN GENTLY AND COVERED HER IN LEAVES AND BITS OF WOOL AND OLD FEATHERS TO KEEP HER WARM AND DRY AND THEY SCOOPED UP WATER AND DROPPED IT ON HER LITTLE BEAK TO KEEP HER COOL. ALL DAY THEY WATCHED OVER HER — AND ALL THROUGH THE NIGHT AS WELL.

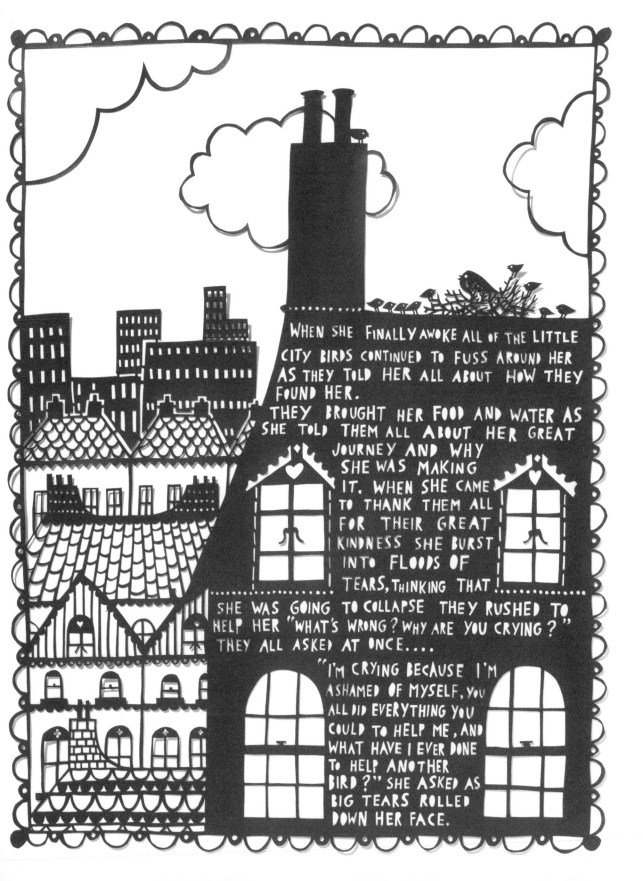

WHEN SHE FINALLY AWOKE ALL OF THE LITTLE CITY BIRDS CONTINUED TO FUSS AROUND HER AS THEY TOLD HER ALL ABOUT HOW THEY FOUND HER.
THEY BROUGHT HER FOOD AND WATER AS SHE TOLD THEM ALL ABOUT HER GREAT JOURNEY AND WHY SHE WAS MAKING IT. WHEN SHE CAME TO THANK THEM ALL FOR THEIR GREAT KINDNESS SHE BURST INTO FLOODS OF TEARS, THINKING THAT SHE WAS GOING TO COLLAPSE THEY RUSHED TO HELP HER "WHAT'S WRONG? WHY ARE YOU CRYING?" THEY ALL ASKED AT ONCE....

"I'M CRYING BECAUSE I'M ASHAMED OF MYSELF, YOU ALL DID EVERYTHING YOU COULD TO HELP ME, AND WHAT HAVE I EVER DONE TO HELP ANOTHER BIRD?" SHE ASKED AS BIG TEARS ROLLED DOWN HER FACE.

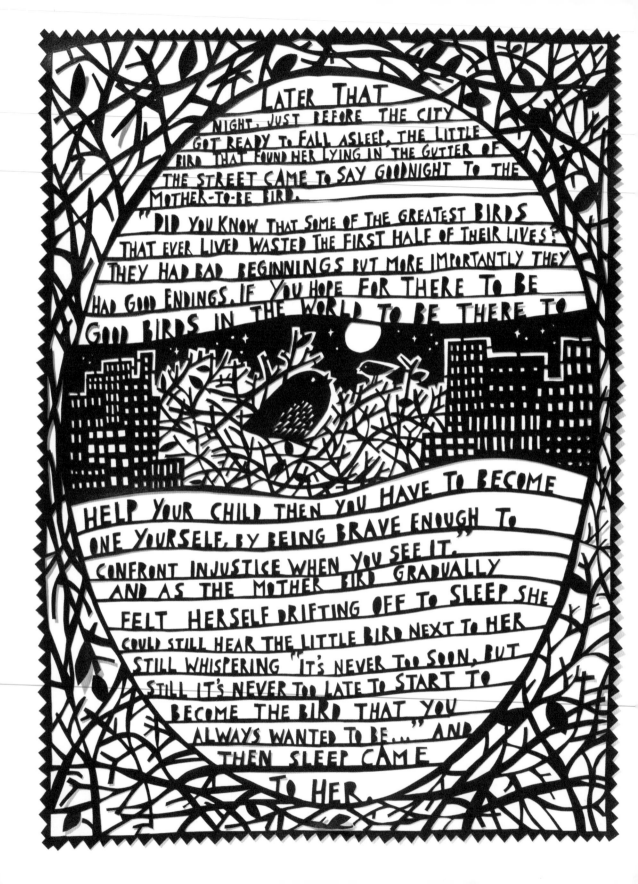

LATER THAT NIGHT, JUST BEFORE THE CITY GOT READY TO FALL ASLEEP, THE LITTLE BIRD THAT FOUND HER LYING IN THE GUTTER OF THE STREET CAME TO SAY GOODNIGHT TO THE MOTHER-TO-BE BIRD.

"DID YOU KNOW THAT SOME OF THE GREATEST BIRDS THAT EVER LIVED WASTED THE FIRST HALF OF THEIR LIVES? THEY HAD BAD BEGINNINGS BUT MORE IMPORTANTLY THEY HAD GOOD ENDINGS. IF YOU HOPE FOR THERE TO BE GOOD BIRDS IN THE WORLD TO BE THERE TO HELP YOUR CHILD THEN YOU HAVE TO BECOME ONE YOURSELF, BY BEING BRAVE ENOUGH TO CONFRONT INJUSTICE WHEN YOU SEE IT."

AND AS THE MOTHER BIRD GRADUALLY FELT HERSELF DRIFTING OFF TO SLEEP SHE COULD STILL HEAR THE LITTLE BIRD NEXT TO HER STILL WHISPERING "IT'S NEVER TOO SOON, BUT STILL IT'S NEVER TOO LATE TO START TO BECOME THE BIRD THAT YOU ALWAYS WANTED TO BE..." AND THEN SLEEP CAME TO HER.

THE FOLLOWING MORNING SHE WOKE BEFORE ALL OF THE OTHER BIRDS AND FLEW OFF UP INTO THE SKY "I FEEL TERRIBLE NOT SAYING GOODBYE TO YOU MY FRIENDS," SHE THOUGHT TO HERSELF "BUT I MUST FINISH THE JOURNEY THAT I SET OUT ON." AND ALL DAY SHE CIRCLED OVER THE ENTIRE CITY UNTIL SHE FINALLY SAW WHAT SHE WAS SEEKING.

DOWN SHE SWOOPED AND FLEW THROUGH AN OPEN WINDOW. (I CAN'T BEGIN TO EXPLAIN HOW THIS IS ABOUT THE MOST DANGEROUS THING A BIRD CAN DO! HUMANS HATE BIRDS BEING INSIDE THEIR BUILDINGS!) SHE PICKED UP A LARGE KEY OFF A HOOK ON THE WALL AND QUICKLY FLEW OUT OF THE ROOM FASTER THAN SHE EVER THOUGHT SHE COULD, HOLDING IT TIGHTLY IN HER LITTLE BEAK.

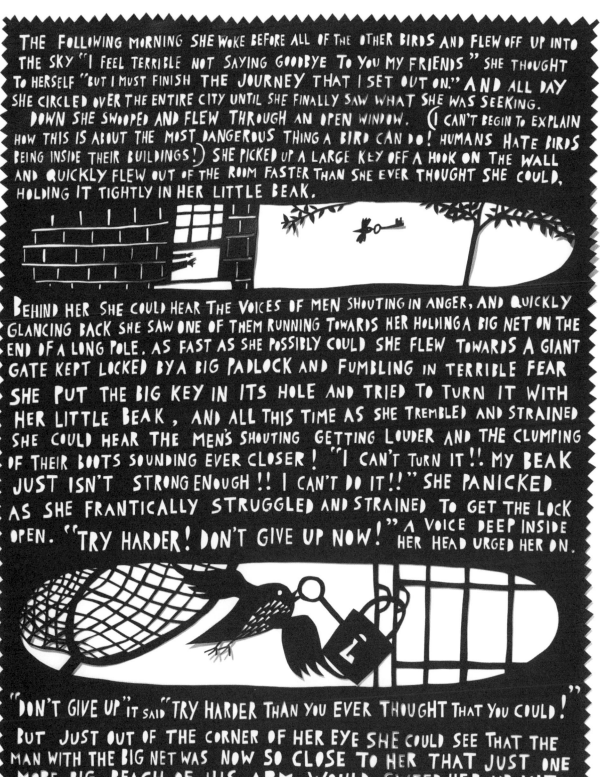

BEHIND HER SHE COULD HEAR THE VOICES OF MEN SHOUTING IN ANGER, AND QUICKLY GLANCING BACK SHE SAW ONE OF THEM RUNNING TOWARDS HER HOLDING A BIG NET ON THE END OF A LONG POLE. AS FAST AS SHE POSSIBLY COULD SHE FLEW TOWARDS A GIANT GATE KEPT LOCKED BY A BIG PADLOCK AND FUMBLING IN TERRIBLE FEAR SHE PUT THE BIG KEY IN ITS HOLE AND TRIED TO TURN IT WITH HER LITTLE BEAK, AND ALL THIS TIME AS SHE TREMBLED AND STRAINED SHE COULD HEAR THE MEN'S SHOUTING GETTING LOUDER AND THE CLUMPING OF THEIR BOOTS SOUNDING EVER CLOSER! "I CAN'T TURN IT!! MY BEAK JUST ISN'T STRONG ENOUGH!! I CAN'T DO IT!!" SHE PANICKED. AS SHE FRANTICALLY STRUGGLED AND STRAINED TO GET THE LOCK OPEN. "TRY HARDER! DON'T GIVE UP NOW!" A VOICE DEEP INSIDE HER HEAD URGED HER ON.

"DON'T GIVE UP" IT SAID "TRY HARDER THAN YOU EVER THOUGHT THAT YOU COULD!" BUT JUST OUT OF THE CORNER OF HER EYE SHE COULD SEE THAT THE MAN WITH THE BIG NET WAS NOW SO CLOSE TO HER THAT JUST ONE MORE BIG REACH OF HIS ARM WOULD SWEEP HER UP INTO HIS NET AS SHE TRIED WITH ALL HER HEART TO MAKE THE KEY TURN

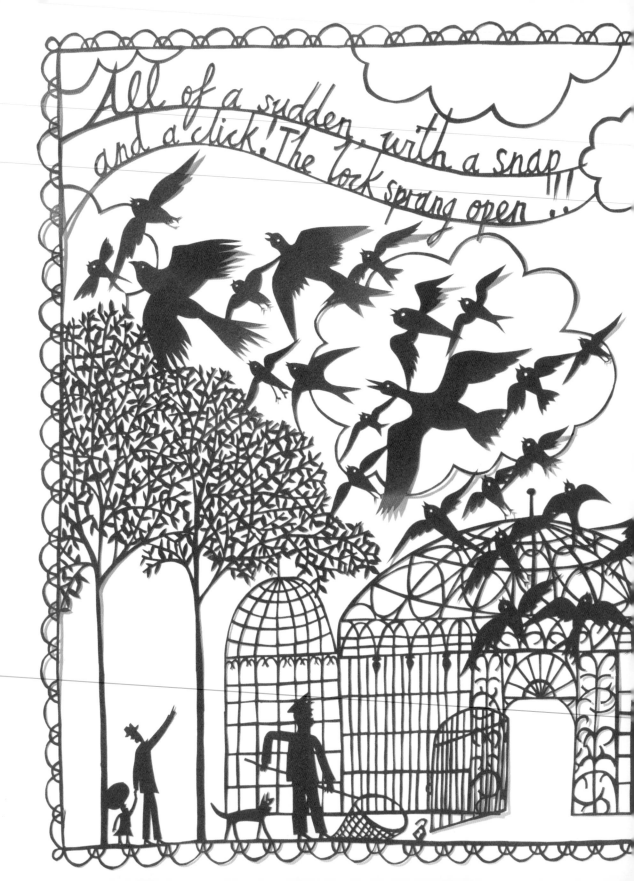

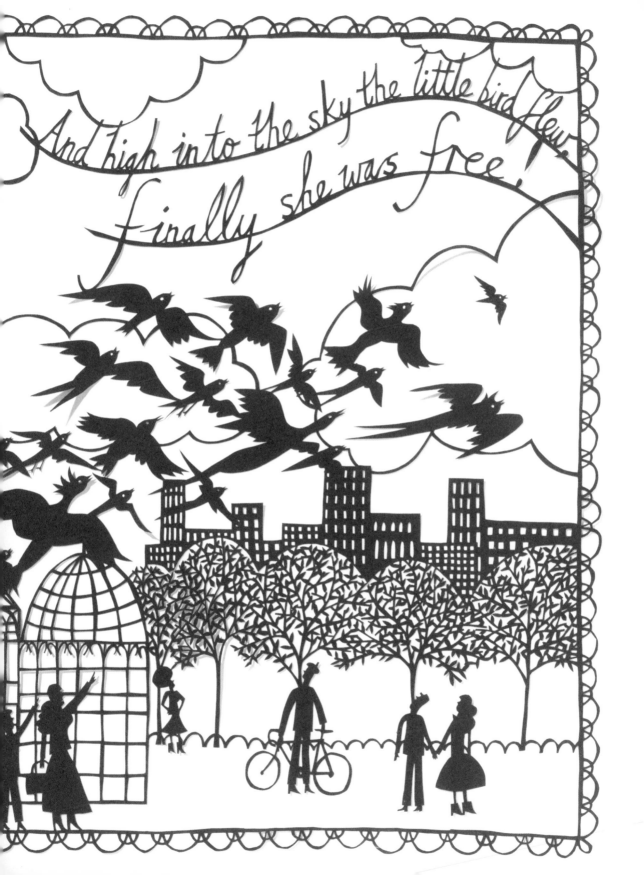

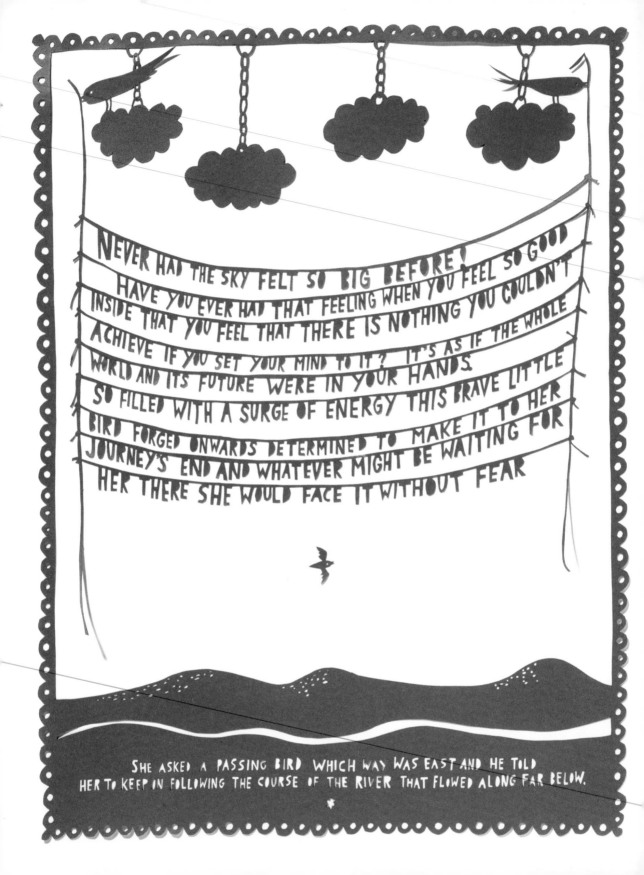

NEVER HAD THE SKY FELT SO BIG BEFORE! HAVE YOU EVER HAD THAT FEELING WHEN YOU FEEL SO GOOD INSIDE THAT YOU FEEL THAT THERE IS NOTHING YOU COULDN'T ACHIEVE IF YOU SET YOUR MIND TO IT? IT'S AS IF THE WHOLE WORLD AND ITS FUTURE WERE IN YOUR HANDS. SO FILLED WITH A SURGE OF ENERGY THIS BRAVE LITTLE BIRD FORGED ONWARDS DETERMINED TO MAKE IT TO HER JOURNEY'S END AND WHATEVER MIGHT BE WAITING FOR HER THERE SHE WOULD FACE IT WITHOUT FEAR

SHE ASKED A PASSING BIRD WHICH WAY WAS EAST AND HE TOLD HER TO KEEP ON FOLLOWING THE COURSE OF THE RIVER THAT FLOWED ALONG FAR BELOW.

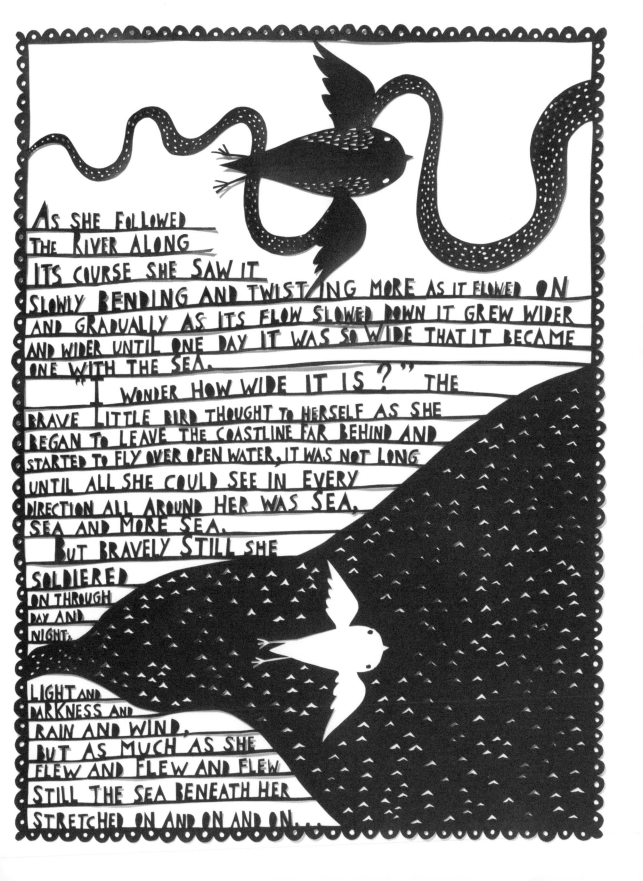

As she followed the river along its course she saw it slowly bending and twisting more as it flowed on and gradually as its flow slowed down it grew wider and wider until one day it was so wide that it became one with the sea.

"I wonder how wide it is?" the brave little bird thought to herself as she began to leave the coastline far behind and started to fly over open water, it was not long until all she could see in every direction all around her was sea, sea and more sea.

But bravely still she soldiered on through day and night, light and darkness and rain and wind, but as much as she flew and flew and flew still the sea beneath her stretched on and on and on...

DAY AFTER DAY THE LITTLE BIRD FLEW ON OVER THE ENDLESS WAVES. IT SEEMED AS IF THE SEA REALLY DID HAVE NO OTHER SHORE AND WOULD JUST GO ON FOR EVER AND EVER. THE SKY GREW DARKER AND MORE CLOUDY AS SHE FLEW INTO A DENSE FOG AND THE LITTLE BIRD FELT NOT ONLY EXHAUSTED BUT LOST AND CONFUSED AS WELL, HER TINY WINGS GREW MORE AND MORE TIRED AND SHE KNEW THAT SHE COULD NOT GO MUCH FURTHER. AS HER STRENGTH FAILED HER SHE COULD FEEL HERSELF SLOWLY FALLING FROM THE SKY "SO THIS IS HOW IT ALL ENDS! DROWNING IN THE MIDDLE OF A VAST OCEAN - TOTALLY UNNOTICED AND ALONE" SHE THOUGHT TO HERSELF "BUT AFTER ALL OF MY FEARS AND WORRIES NOW I FEEL I'M NOT SCARED AT ALL" AND AS SHE GRADUALLY FELL THERE CAME ON THE WIND THE MOST BEAUTIFUL SOUND SHE HAD EVER HEARD AND THROUGH THE CLOUDY FOG THERE APPEARED THE VISION OF A SMILING FACE, THE SAME AS SHE HAD HEARD AND SEEN IN HER DREAM SO LONG AGO.

"I NEVER THOUGHT THAT THE MEANING OF MY DREAM WAS NOT TO DO WITH THE BIRTH OF MY CHILD BUT THE END OF MY OWN LIFE, AND THAT IT WAS MY DESTINY TO FLY OUT TO GREET IT, AND THOUGH I'LL NEVER GET TO SEE MY CHILD'S FACE EMERGE FROM ITS EGG I NOW KNOW MY JOURNEY HAS NOT BEEN IN VAIN, I WILL FLY TO MY DEATH HAPPY KNOWING THAT THERE ARE SO MANY GOOD BIRDS IN THE WORLD THAT WILL BE THERE TO HELP MY CHILD THROUGHOUT ITS LIFE"

AND WITH THE VERY LAST OUNCE OF STRENGTH IN HER FRAIL BODY SHE PUSHED ON TOWARDS THE MYSTERIOUS FACE AND THE BEAUTIFUL SOUND EMANATING FROM IT, AND AS SHE FLEW SHE REMEMBERED HER FRIEND THE PELICAN AND THE RUPPELL'S GRIFFON, THE BIRDS IN THE BIG CITY AND THE BIRDS FROM THE CEMETERY, ALL THE MIGRATING BIRDS AND AS SHE FELL FROM THE SKY TOWARDS THE WILD CHURNING WAVES SHE SMILED AS SHE RECALLED THEIR KINDNESS.

As the little bird fell she dropped through the bottom of the giant cloud of fog into clear sky. There below her was not the face from her dream but the coastline of another land. She had at last reached the other side of the sea. The mouth that she had imagined the glorious sounds coming from was really the mouth of a river flowing into the sea, and down towards it and the beautiful music she flew...

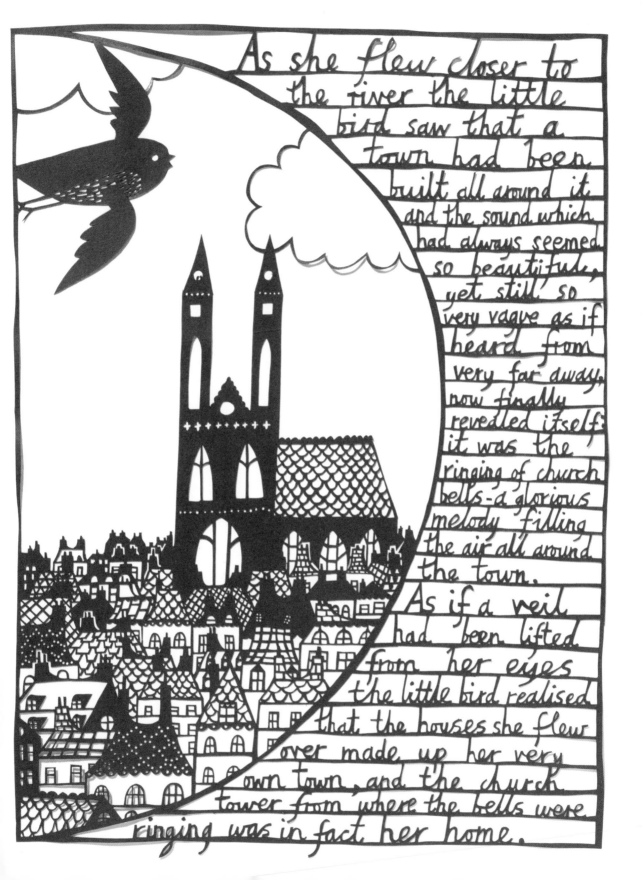

As she flew closer to the river the little bird saw that a town had been built all around it and the sound which had always seemed so beautiful, yet still so very vague as if heard from very far away, now finally revealed itself: it was the ringing of church bells-a glorious melody filling the air all around the town.

As if a veil had been lifted from her eyes the little bird realised that the houses she flew over made up her very own town, and the church tower from where the bells were ringing was in fact her home.

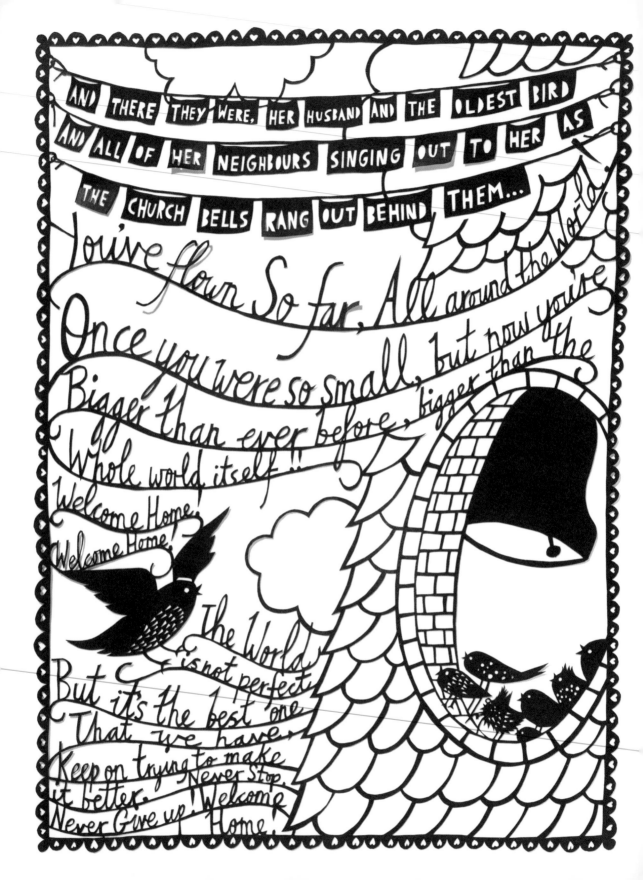

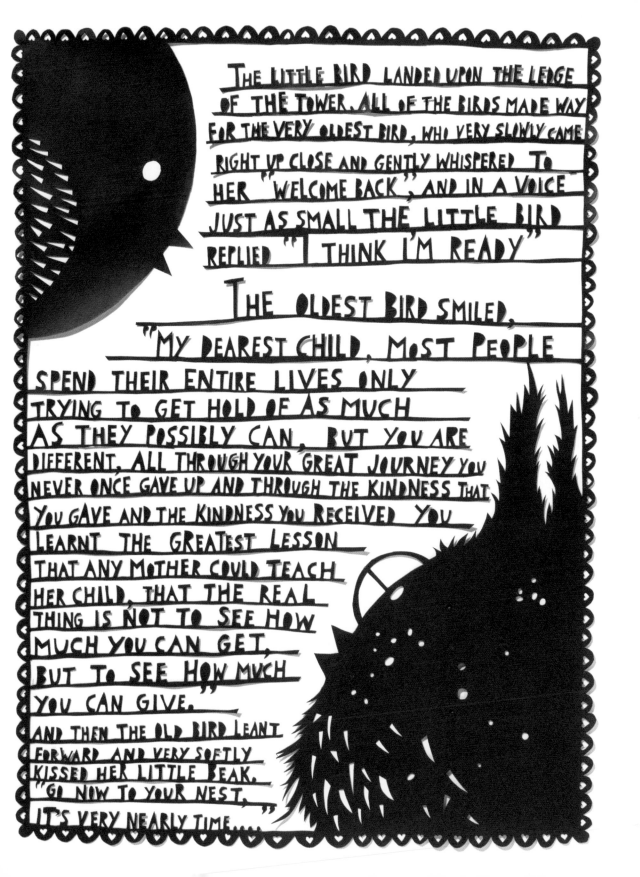

THE LITTLE BIRD LANDED UPON THE LEDGE OF THE TOWER. ALL OF THE BIRDS MADE WAY FOR THE VERY OLDEST BIRD, WHO VERY SLOWLY CAME RIGHT UP CLOSE AND GENTLY WHISPERED TO HER "WELCOME BACK", AND IN A VOICE JUST AS SMALL THE LITTLE BIRD REPLIED "I THINK I'M READY"

THE OLDEST BIRD SMILED, "MY DEAREST CHILD, MOST PEOPLE SPEND THEIR ENTIRE LIVES ONLY TRYING TO GET HOLD OF AS MUCH AS THEY POSSIBLY CAN, BUT YOU ARE DIFFERENT, ALL THROUGH YOUR GREAT JOURNEY YOU NEVER ONCE GAVE UP AND THROUGH THE KINDNESS THAT YOU GAVE AND THE KINDNESS YOU RECEIVED YOU LEARNT THE GREATEST LESSON THAT ANY MOTHER COULD TEACH HER CHILD, THAT THE REAL THING IS NOT TO SEE HOW MUCH YOU CAN GET, BUT TO SEE HOW MUCH YOU CAN GIVE.

AND THEN THE OLD BIRD LEANT FORWARD AND VERY SOFTLY KISSED HER LITTLE BEAK. "GO NOW TO YOUR NEST. IT'S VERY NEARLY TIME..."

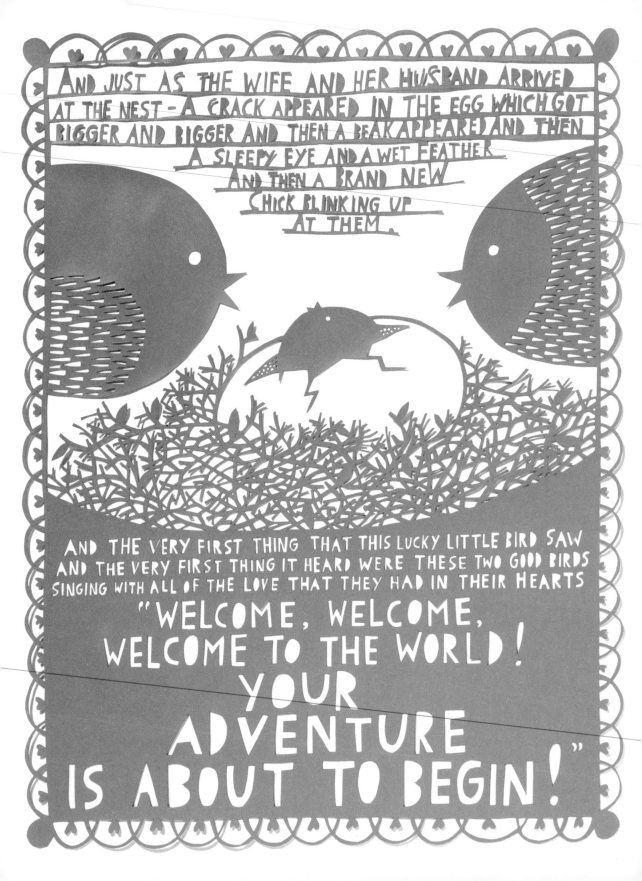

AND JUST AS THE WIFE AND HER HUSBAND ARRIVED AT THE NEST - A CRACK APPEARED IN THE EGG WHICH GOT BIGGER AND BIGGER AND THEN A BEAK APPEARED AND THEN A SLEEPY EYE AND A WET FEATHER AND THEN A BRAND NEW CHICK BLINKING UP AT THEM.

AND THE VERY FIRST THING THAT THIS LUCKY LITTLE BIRD SAW AND THE VERY FIRST THING IT HEARD WERE THESE TWO GOOD BIRDS SINGING WITH ALL OF THE LOVE THAT THEY HAD IN THEIR HEARTS

"WELCOME, WELCOME, WELCOME TO THE WORLD! YOUR ADVENTURE IS ABOUT TO BEGIN!"

FOR

&

First published in the United States in 2013 by Chronicle Books, LLC.
First published in Great Britain in 2011 by Hodder & Stoughton, Ltd.
Copyright © 2011 by Rob Ryan.

Library of Congress Cataloging-in-Publication Data is available.

ISBN: 978-1-4521-1218-3

Manufactured in China.

Photography by Packshot Factory

10 9 8 7 6 5 4 3 2 1

Chronicle Books LLC
680 Second Street
San Francisco, CA 94107
www.chroniclebooks.com

Thanks to Hazel, Libby, Jackie, Ellie, Michelle, Kei, Amy, Joanna, and Eileen.
And a special thanks and love to the wonderful Jocasta Hamilton.